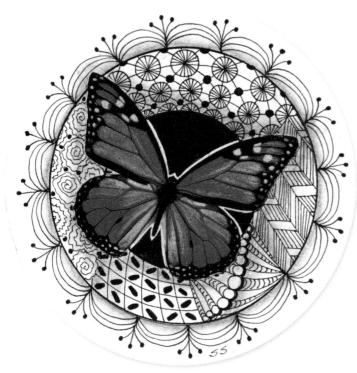

by Suzanne McNeill

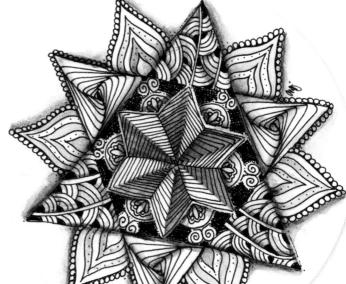

by Angie Vangalis

Zendalas

A Zendala is a form of mandala that is drawn using tangles to fill each section of a circle. These round gems are fascinating. In this book, talented Certified Zentangle Teachers (CZTs) generously share their secrets for creating basic circle designs plus how to add color, resist, layers, and more.

With Zentangle, the process is simple and relaxing (really!). Similar to handwriting, each person draws tangles in a different manner. Be inspired by the designs in this book, and enjoy creating your own art.

Zen mandalas

For centuries, mandala circles have been used to connect the spirit with the divine, offering symbols found in nature as subjects of contemplation. Drawing a mandala helps one discover true inner self and balance. These special circles provide an opportunity to explore ancient teachings. Gently appreciate the uniqueness of your experience in the world of ten thousand things as you create beautiful drawings that reflect your vision, and you will discover the infinite possibilities that spring from inner peace. When drawn on a Zentangle tile, each beautiful circle is called a Zendala.

by Margaret Bremner

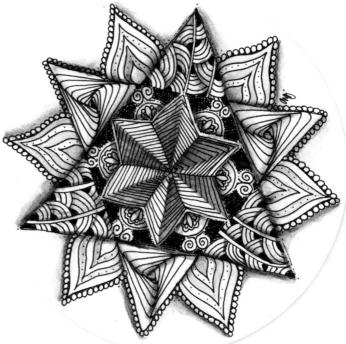

ZIAs

Traditional Zentangle designs are nonobjective and have no recognizable shape or orientation. The string divides the sections. ZIA is an abbreviation for Zentangle-Inspired Art. Anything tangled with color, not on a square tile, or with a specific orientation is considered a ZIA.

Traditional Zentangle

A very simple ritual is part of every classic Zentangle piece.

- 1. Make a dot in each corner of your paper tile with a pencil.
- 2. Connect the dots to form a basic frame. The lines don't need to be straight.
- **3.** Draw a string, or guideline, with the pencil. The shape can be a zigzag, swirl, X, circle, or just about anything that divides the area into sections. It represents the thread that connects all the patterns and events that run through life. The string will not be erased but become part of the design.
- **4.** Use a black pen to draw tangles, or patterns, into the sections formed by the string.

Tip: Rotate the paper tile as you fill each section with a tangle.

Starting a Zendala

- **1.** Use a pencil to form a round border with a circle template, compass, or lid. Add a dot in the center.
- **2.** Now use the same circular shape to connect the center dot to the border, forming a partial circle.
- 3. Use the same circular shape two more times, always connecting to the center dot.
- **4.** Use the same shape to divide the large sections into pleasing shapes.
- **5.** Draw a smaller circle, to divide the large sections again.
- **6.** Switch to a black pen and draw a tangle in each section. When you cross a line, change the tangle. It is OK to leave some sections blank.

What you'll need to get started

- a pencil
- a black permanent marker a Pigma MICRON 01 pigment ink pen by Sakura is suggested
- smooth white art paper—a Zentangle die-cut paper tile is suggested (3½" x 3½" [9 x 9cm]); for Zendalas, a Zentangle die-cut 4½"-diameter circular tile is suggested

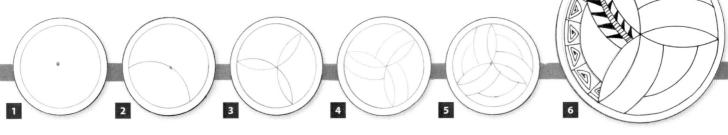

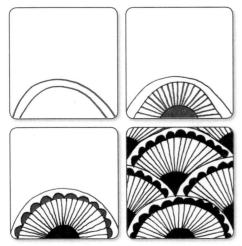

Citrus

- **1.** Draw two large half-circles along one edge.
- 2. Draw a smaller half-circle in the center. Color the center black. Draw radiating lines from the center to the border.
- **3.** Draw small humps in the border. Color the shapes black.
- **4.** Fill the space with these shapes.

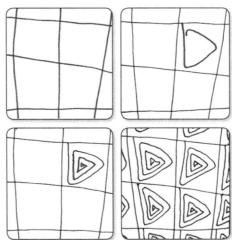

Time Warp

- 1. Draw a grid—curved lines are OK.
- **2.** Draw a not-quite-closed triangle in each square.
- Draw each triangle in a continuous line until you reach the center with a tiny triangle.
- **4.** Fill each section of the grid.

Each tangle is a unique artistic design, and there are hundreds of variations. Start with basic tangles, then create your own.

With the Zentangle method, no eraser is needed. Just as in life, we cannot erase events and mistakes. Instead, we must build upon them and make improvements.

Life is a building process. All events and experiences are incorporated into our learning process and into our life patterns.

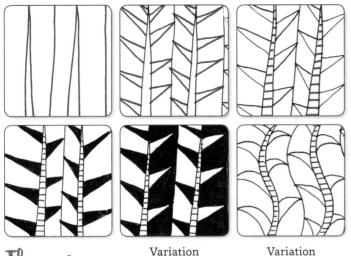

- **1.** Draw a line to divide the space into vertical rows. Draw a tall triangle section in the center of each vertical row.
- **2.** Draw alternating horizontal triangles on each side of the tall sections to resemble thorns.
- 3. Fill each tall section with horizontal lines.
- 4. Color the thorns black.

Variation 1: Color alternating thorns and background sections black.

Variation 2: Follow the steps above but using wavy lines instead.

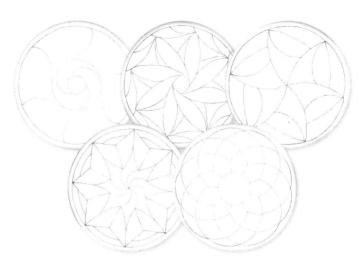

Pre-strung tiles—Zendala tiles and square tiles are available from zentangle.com with pre-printed strings so you can begin drawing tangles right away.

fractice a new tangle pattern and draw a new tile design every day.

Shading Your Zentangle

Shading adds a touch of dimension and is very easy to do. First use the side of your pencil to gently color areas and details gray. Then rub the pencil areas with a paper shading tool, a finger, or another tool to blend the gray. Use shading sparingly. Be sure to leave some sections white. You can also try adding shading along the right and bottom edges of your finished shape. Make the shading about 1/8" (0.5cm) wide to visually raise the tangles off the page.

Helpful Tips to Remember

- Hold your pen lightly.
- Remember to breathe.
- Be deliberate when making a stroke.
- Take your time drawing tangles.
- Draw your strokes fluidly.
- Turn your tile from time to time.
- Stand back from your tile to view your work.
- There are no mistakes, only opportunities.
- It is okay to leave your work and come back later.
- Enjoy the process.

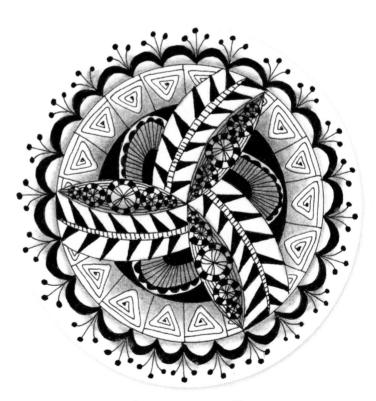

by Suzanne McNeill

Margaret Bremner, CZT

Margaret tangles every day... it keeps her calm and sane. She has always loved detail and patterns, and her discovery of Zentangle was an immediate click. Margaret is a prolific artist in acrylic, pen-and-ink, and mixed media. She is an active Zentangle teacher residing in Saskatoon, Canada.

email: margaret.bremner.artist@gmail.com **website:** www.artistsincanada.com/bremner **blog:** enthusiasticartist.blogspot.com

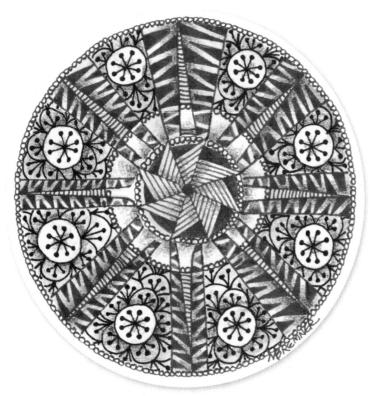

by Margaret Bremner

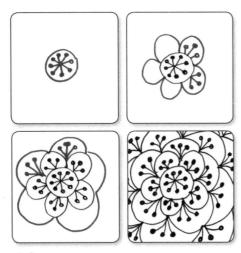

Blooms

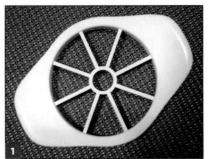

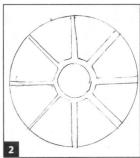

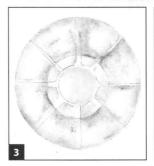

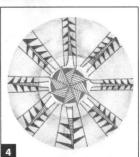

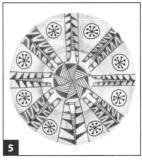

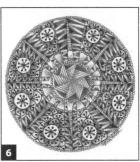

Colored Zendala

- 1. Use an apple corer.
- 2. Draw the rays in pencil. It will be a bit uneven. Don't worry about it.
- 3. Add color with Derwent Aquatone (or other) water-soluble pencils (yellow, deep pink, sky blue, purple). Use water and a small brush to blend the pencil into a wash. Note: Purple is stronger than blue and pink, so use it sparingly.
- 4. Add tangles with color MICRON 01 pens. Try to coordinate the wash color with an ink color, and you will probably want to choose colors according to mandala segments. Use purple over purple areas.
- 5. Add filler tangles in green and orange.
- **6.** Add shading with Prismacolor pencils in violet, fuchsia, and orange.

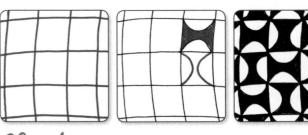

Slender

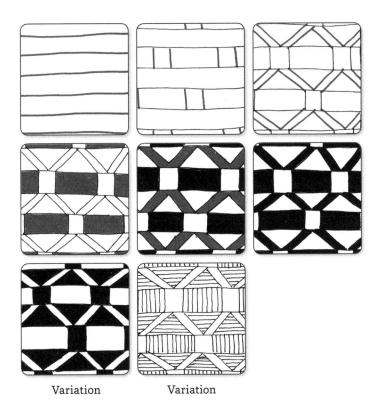

Tessera

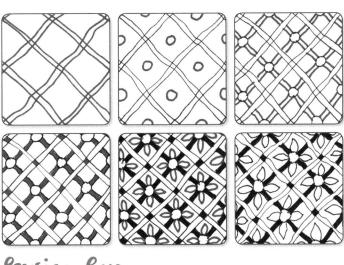

Persian Ruz

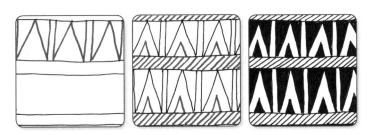

Teepee

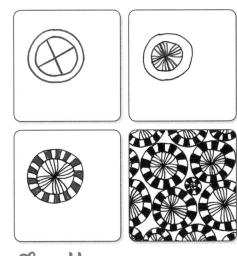

florette

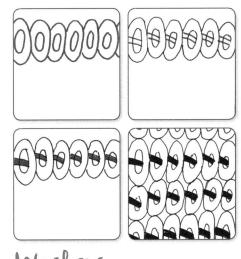

Washers

Puff Border

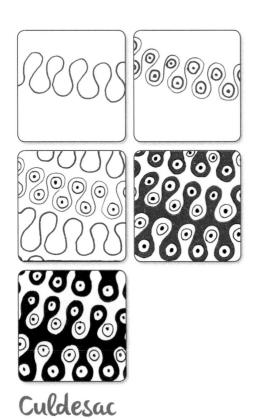

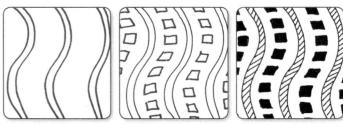

Traffic

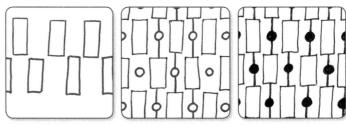

Tied Together

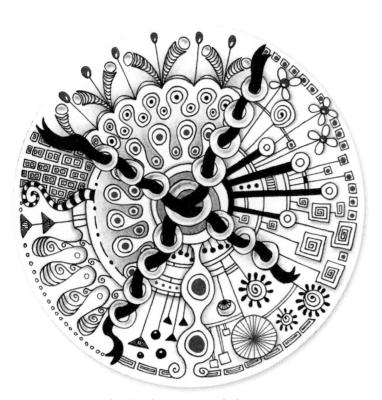

by Sandy Steen Bartholomew

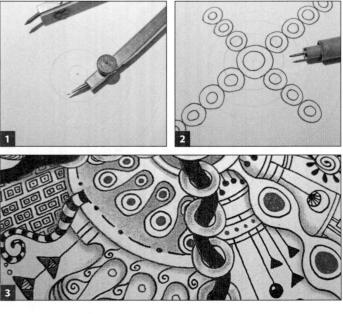

ZenDangle Circle

- Draw circles using a compass with a pencil tip.
 Use a black MICRON 01 pen. Starting from the center, draw tangles radiating out.
- 3. Add tangles dangling out from the center. Turn the tile as you work. Use a red MICRON to add spots of color. Shade areas behind some tangles.

Inspired by 'ZenDangles' art from the book Zenspirations by Joanne Fink.

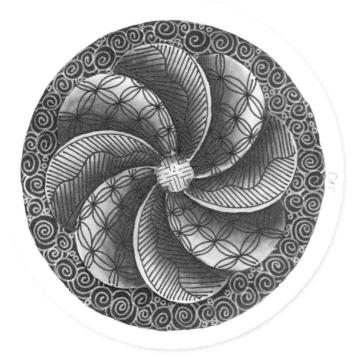

by Sue Jacobs

Watercolor Technique

Use water-based markers (Sakura KOI or Tombow) to shade areas of the donut with color. Use color MICRON 01 pens to draw tangles.

- **1.** Apply color from a water-based marker to a piece of plastic.
- 2. Using a brush filled with water, dampen the entire section you are working on.
- Pick up some color from the plastic with a damp brush and apply color to one side of a section.
- 4. Wipe out extra color and use the brush to spread color over the section—it will lighten as you go.
- 5. Let dry completely. Repeat these steps if you desire darker shading.

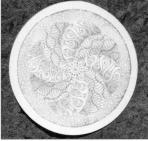

Spirals

Use water-based markers (Sakura or Tombow) to create the initial shading and to define the spirals. Use color MICRON pens to draw tangles. If desired, add extra shading at the end with a coordinating shade of a Prismacolor pencil.

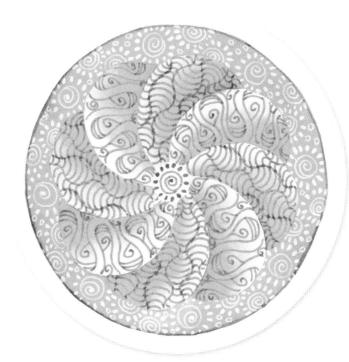

by Sue Jacobs

Sue Jacobs, CZT

Sue lets nature inspire her beautiful art. She is a talented artist and popular demonstrator. Her pink and purple Zendala is an homage to the bright pink peonies in her garden. Her aqua Zendala is reminiscent of sky on a sunny day. Sue teaches Zentangle classes in the Chicago area of Illinois. You can see more of Sue's art on her blog.

email: sj60010@gmail.com blog: suejacobs.blogspot.com

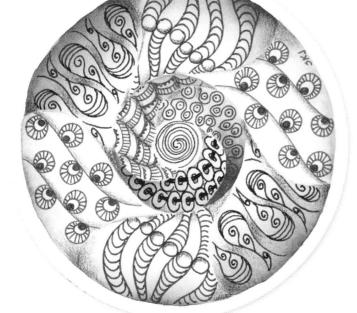

Donut

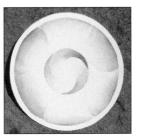

Use water-based markers (Sakura or Tombow) to create the initial shading and to define the sections. Use color MICRON pens to draw tangles. If desired, add extra shading at the end with a coordinating shade of a Prismacolor pencil.

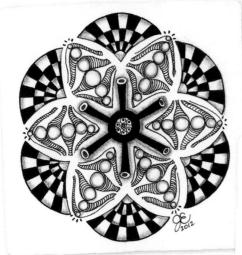

by Julie Evans

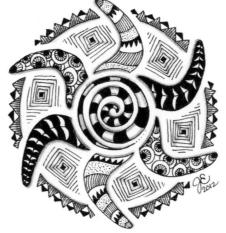

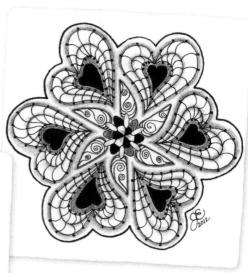

by Julie Evans

by Julie Evans

Julie Evans, CZT

Julie is a graphic artist and Zentangle teacher in Honomu, Hawaii. She is always looking for ways to enable her students to master the art of Zentangle. "I wanted a better way to introduce students to a round format, so with my graphic design background and the help of my Silhouette Cameo digital cutter, I developed... stencils for circles and Zendalas" (available at her Etsy store). These stencils create an outline that is begging to be filled with tangles.

email: julie@kalacreative.com

etsy store: etsy.com/shop/KalaDalasStencils

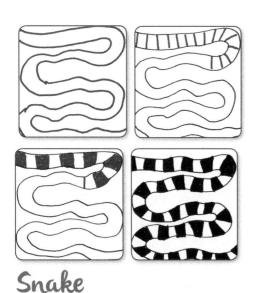

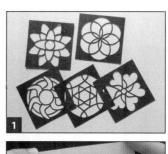

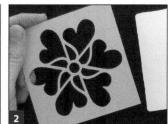

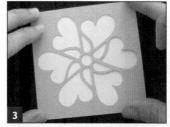

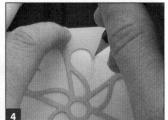

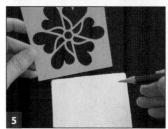

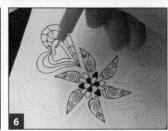

Use a Stencil

- 1. Choose a stencil.
- 2. Gather a paper tile for the stencil.
- 3. Center the stencil on the tile.
- 4. Outline the sections with a pencil.
- 5. Remove the stencil.
- **6.** Fill in the sections with tangles.

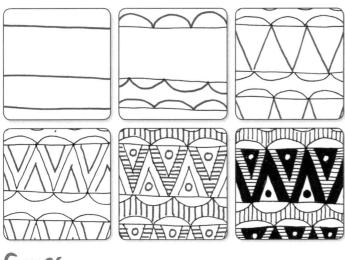

Cones

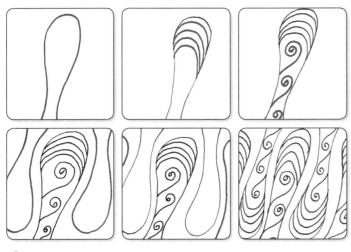

fingers

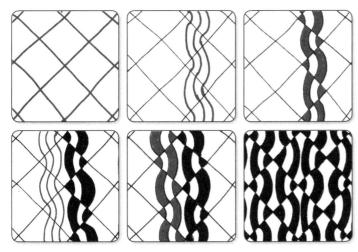

fog Horn

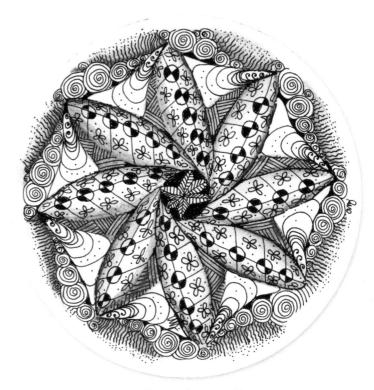

by Angie Vangalis

Punch ShapesPunch butterflies from cardstock, then attach them to a Zendala with foam dots.

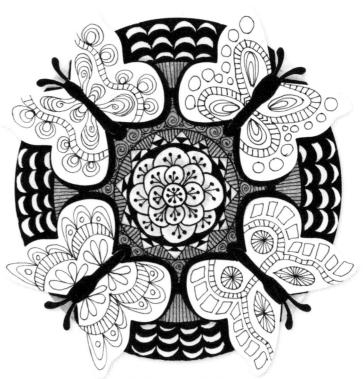

by Suzanne McNeill

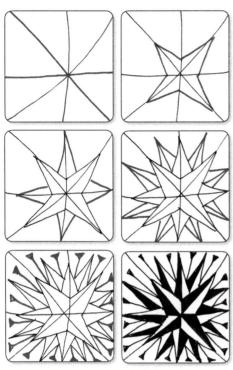

Starburst

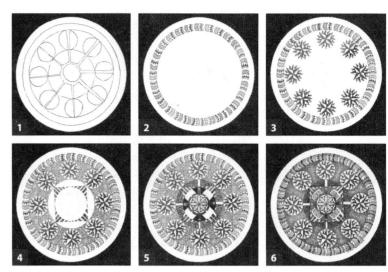

Circle Zendala

- Use a pencil and circle templates to draw sections for a design.
 Use color MICRON 01 pens to fill the outer border with tangles.
 Add a tangle in each circle.
 Draw more tangles to fill the sections.
 Fill in empty spaces with tangles.
 Tint the background by shading with colored pencils.

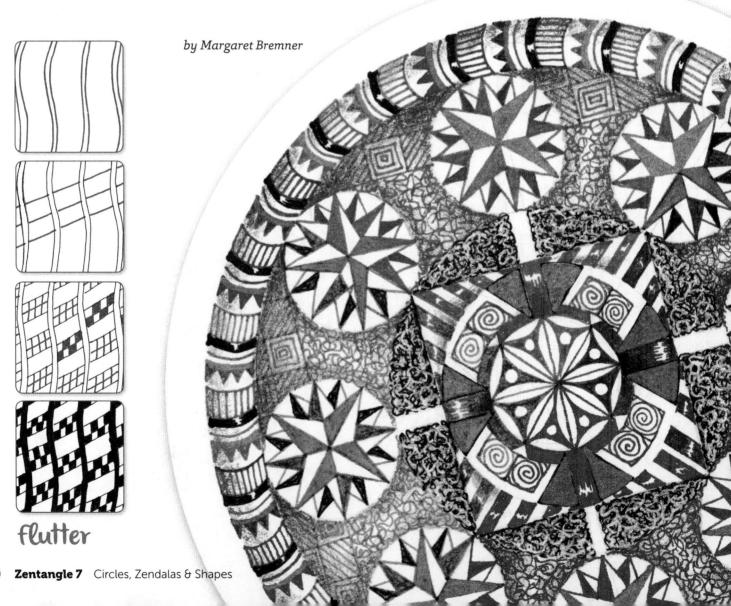

Variation

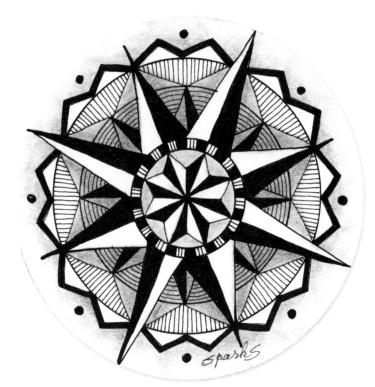

by Suzanne McNeill

This Zendala is enlarged; the actual size is $4\frac{1}{2}$ " in diameter.

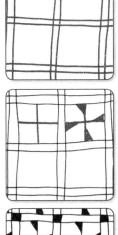

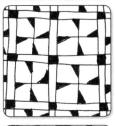

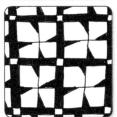

Variation

Cracked Windows

Compass Rose

Elaborate compass rose drawings can be found on historic maps dating back to the 14th century. Sailors connected the points as a navigational aid.

These elaborate symbols divide the circle into thirty-two directional points. In Western culture, the points are simple bisections of the directions of the four winds—East, West, North, and South. Every apprentice seaman was required to master the naming of these points in a test known as *boxing the compass*.

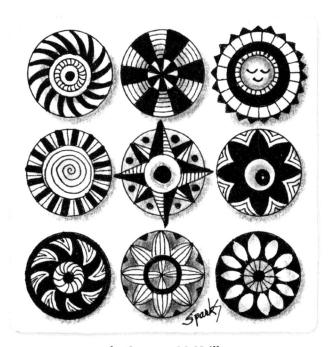

by Suzanne McNeill

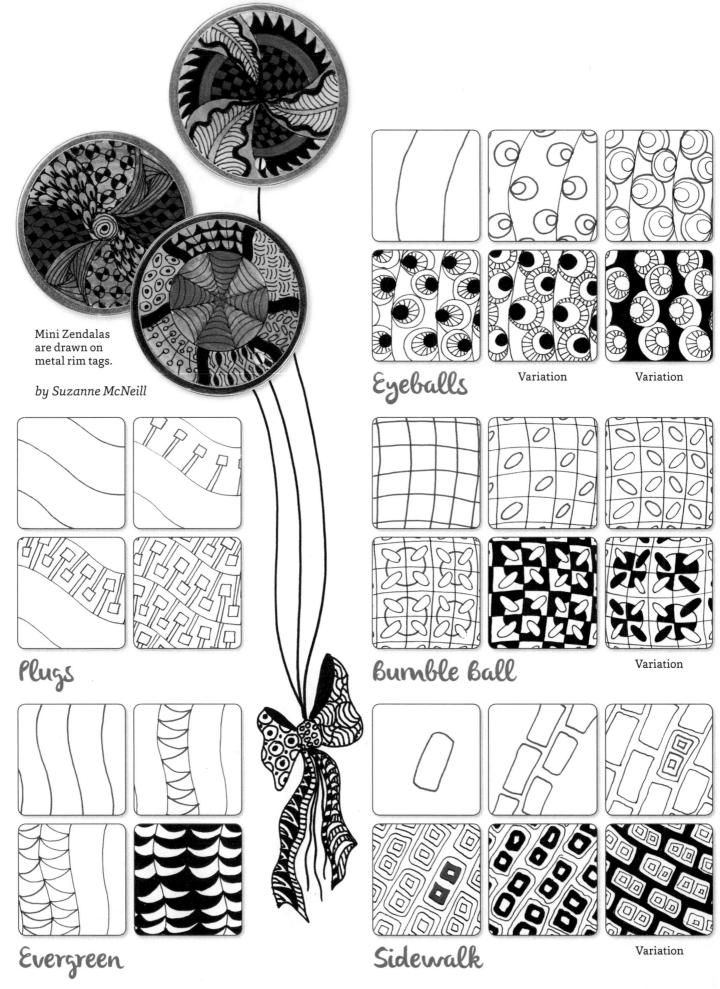

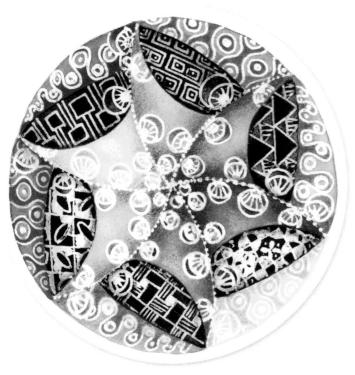

by Sandy Steen Bartholomew

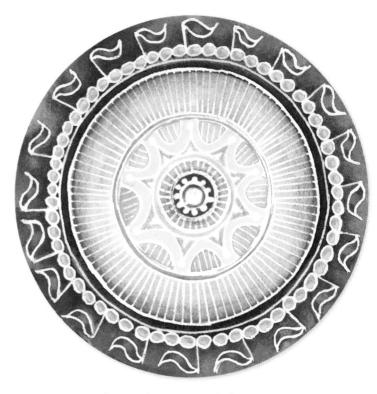

by Sandy Steen Bartholomew

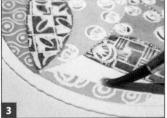

Use a Resist

- Use a Gelly Roll Glaze pen to draw tangles on a pre-strung Zendala tile. Let it dry overnight.
- 2. Fill each section with watercolor paints (I love Yarka brand).
- 3. Let each section dry. Fill all sections with color.
- **4.** Use Prismacolor pencils to add shading to the colored areas.

Holding Hands

Sandy Steen Bartholomew, CZT

Sandy is an author, illustrator, mixed-media artist, and Zentangle teacher from Warner, New Hampshire. Her amazing tangle artisty is showcased in her books, including *Totally Tangled*, *Yoga for the Brain*, *Tangled Fashionista* and in decks of *Tangle Cards*.

email: beezink@tds.net

website: sandysteenbartholomew.com

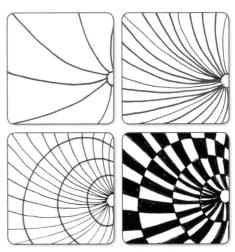

Radio Waves

Angie Vangalis, CZT

Angie is a talented artist, calligrapher, photographer, and teacher of a creative Zentangle class almost every week. She is well known for her creative use of materials for tangling. Angle is also director of Texas Lettering Arts and encourages creativity through visits from guest artists.

email: angie@avgraphics.net

website: angievangalis.wordpress.com

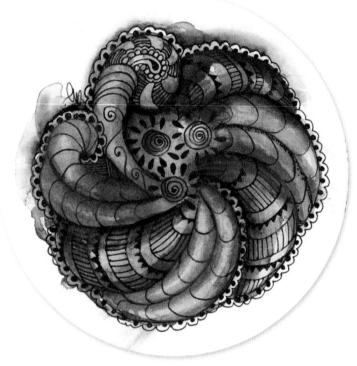

by Angie Vangalis

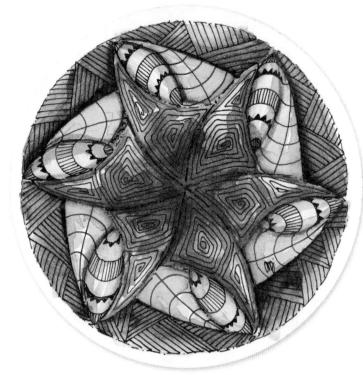

by Angie Vangalis

How to Watercolor

Technique 1: Dampen your brush, then dip it in a color (add a drop of water to each color before you begin). Next, brush color onto the design, section by section.

Technique 2: Make a puddle of water on the tile, then add colors drop by drop. While the tile is still wet, tilt it to encourage the colors to run together in the puddle.

Draw tangles with a black MICRON 01 pen and let dry overnight.

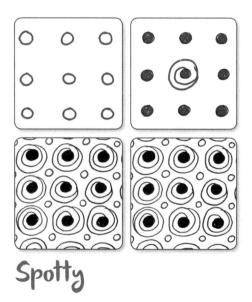

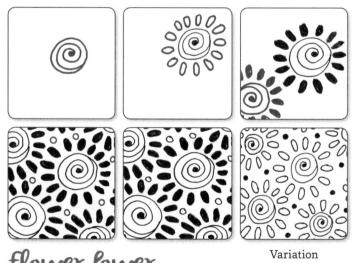

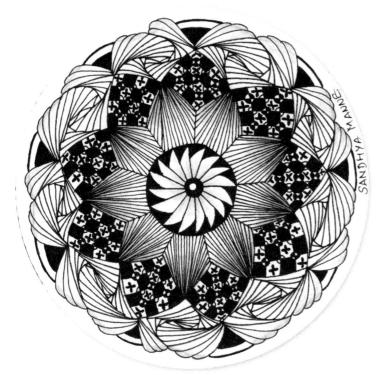

by Sandhya Manne

by Sandhya Manne

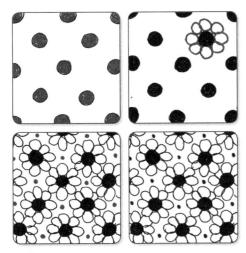

Richardson, and Dallas, Texas. email: sandhyamannestudio@gmail.com

Sandhya Manne, CZT

Sandhya is an Indian artist living in the United States. Though mostly self-taught, she was fortunate to train under some successful artists during her travels around the world. Her works are abstract interpretations of the contemplative aspects from the cultures of India. They reflect peace, joy, and spirituality. She regularly exhibits in the Dallas-Fort Worth area, and her works are in private collections in Canada, the US and India. She offers Zentangle workshops and classes in Mckinney,

website: www.sandhyamanne.com blog: www.zentempletangles.com

flowers

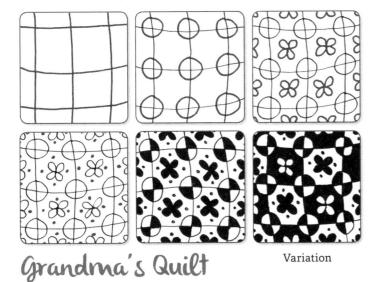

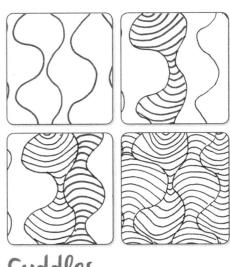

Cuddles

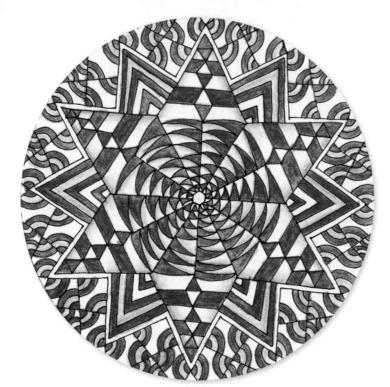

by Sandhya Manne

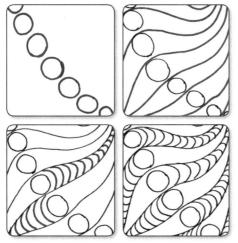

Worm Holes

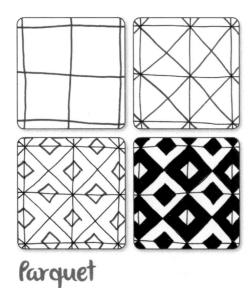

Parasols

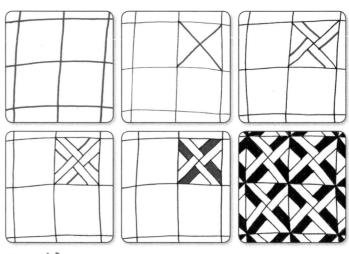

Depth

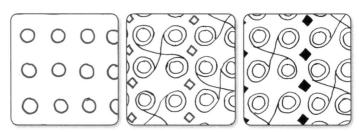

Sprockets

Sprockets Variation

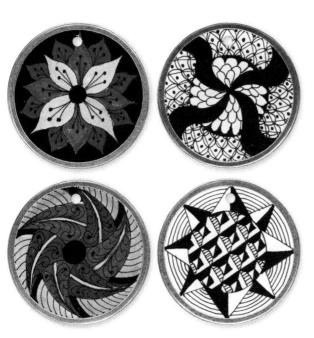

Mini Zendalas

These beautiful little Zendalas are drawn on $2\frac{1}{4}$ " metal rim tags. It is easy to hang each one from a necklace string. See page 18 for more.

by Suzanne McNeill

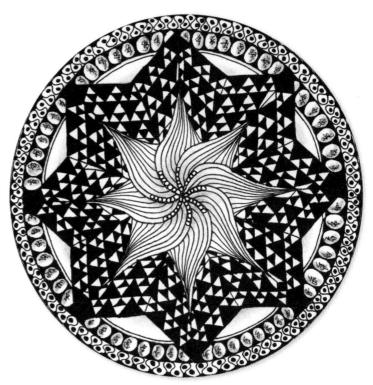

by Sandhya Manne

The Spinner Zendala

This is Sandy's favorite. It is layered and it can spin. Why? Why not!

- 1. Draw tangles on black cardstock with a white gel pen from Ranger. Draw on white cardstock with a black MICRON 01 pen.
- 2. Cut or punch four circles (2¾" and 4¾" black circles, 1¼" and 4½" white circles). Punch a hole in the center of each circle. Trim the edges of the 4½" circle. Layer and attach all the circles together with a brad. Add Stampendous Dot Sparklers stickers along the edges.

Note: These tangles are based on traditional Indian Mehndi patterns.

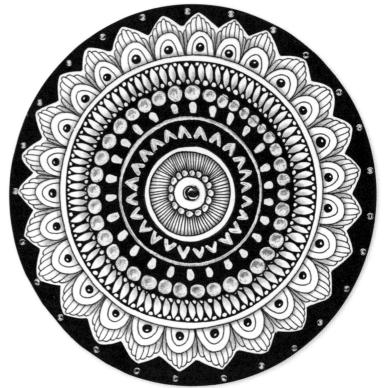

by Sandy Steen Bartholomew

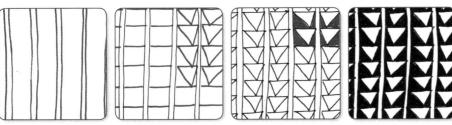

This Way

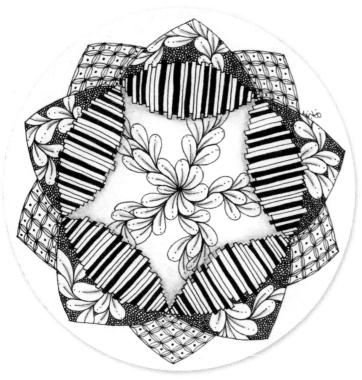

by Erin Koetz Olson

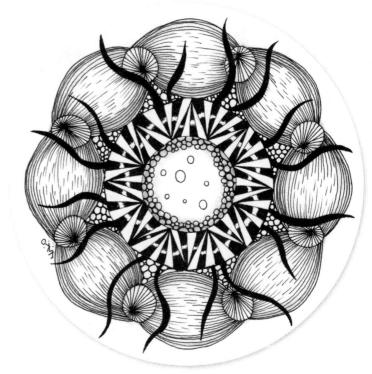

by Erin Koetz Olson

Erin Koetz Olson, CZT

Erin has started a Zendala Dare on her blog, The Bright Owl. Each week she posts a Zendala template perfect for tangling. The templates are available in three sizes (3½", 4½", 8"), and instructions for transferring them to a tile are available on her blog. The templates are free for your personal use and can be downloaded. Erin teaches classes in Northern California Wine country.

email: erin@thebrightowl.com website: thebrightowl.com

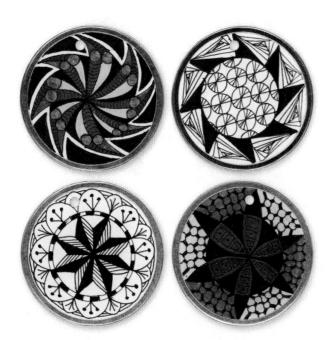

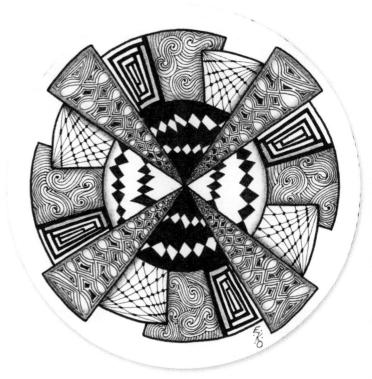

by Erin Koetz Olson

More Mini Zendalas

These beautiful little Zendalas are drawn on $2\frac{1}{4}$ " metal rim tags. It is easy to hang each one from a necklace string. See page 17 for more. by Suzanne McNeill

Zentangle 7 Workbook

Welcome to the Zentangle 7 workbook, where you will be able to put all the knowledge you've gained about Zendalas and using shapes into practice. If you'd like to practice the basics, turn the page to get started with some Draw-it-Yourself tangles. In no time at all, you'll master the tangles you can use in your Zendala designs. If you already have some experience with the tangles, you might want to skip right to the shading and color practice. For tanglers of all levels, there are pages to fill the pre-drawn circular strings with all the tangles you want, and even pages where you can draw your own strings.

You'll notice that these pages have lots of space on them, and it's all for you! Just because a page might direct you to try a certain exercise there doesn't mean you have to. Use any blank space to draw shapes, tangles, or Zentangle art—whatever you want! This is your place to play, experiment, and create.

Don't be intimidated. Just like there are no mistakes in Zentangle, you can't do anything wrong in this workbook. These pages are yours to do with as you please. If a Zendala or tangle does not turn out guite the way you intended, find a new blank space and try again. Take what you learned from your first try and apply it to your second. Keep drawing, and you'll be amazed at the results.

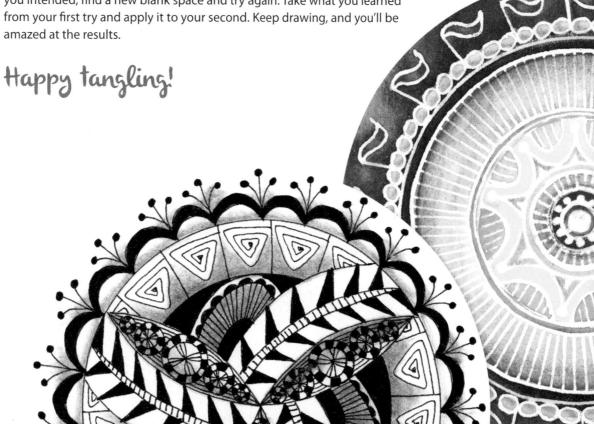

Draw-it-Yourself Tangles

Want to practice the steps of a tangle? Here's your place to experiment. Try recreating the tangles, step by step, and use the extra boxes and space to create your own variations and adaptations.

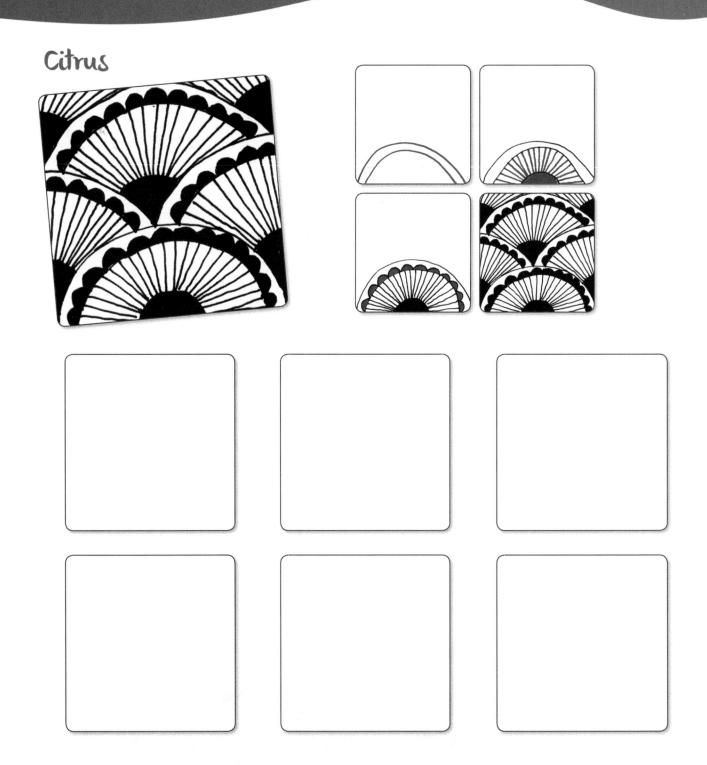

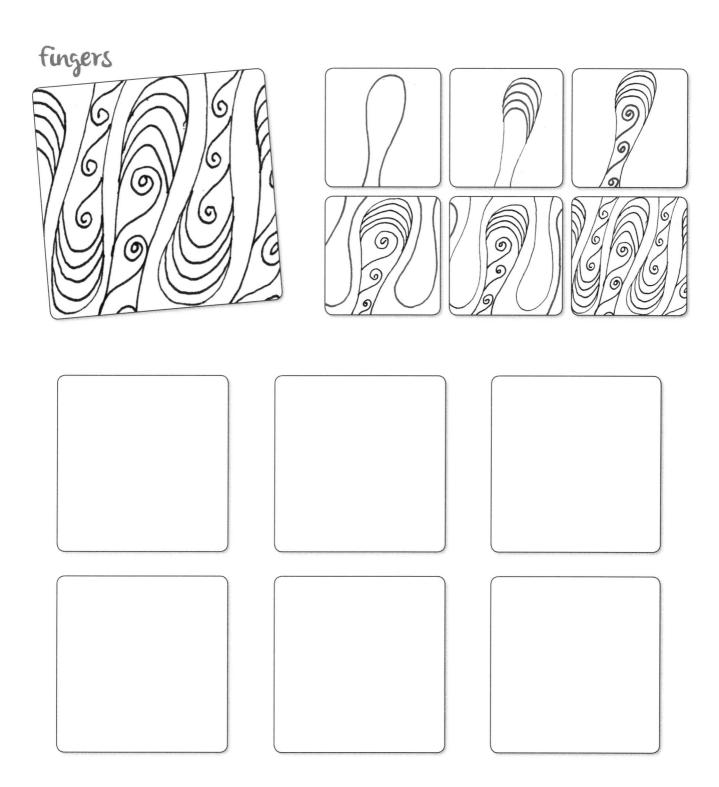

Starburst

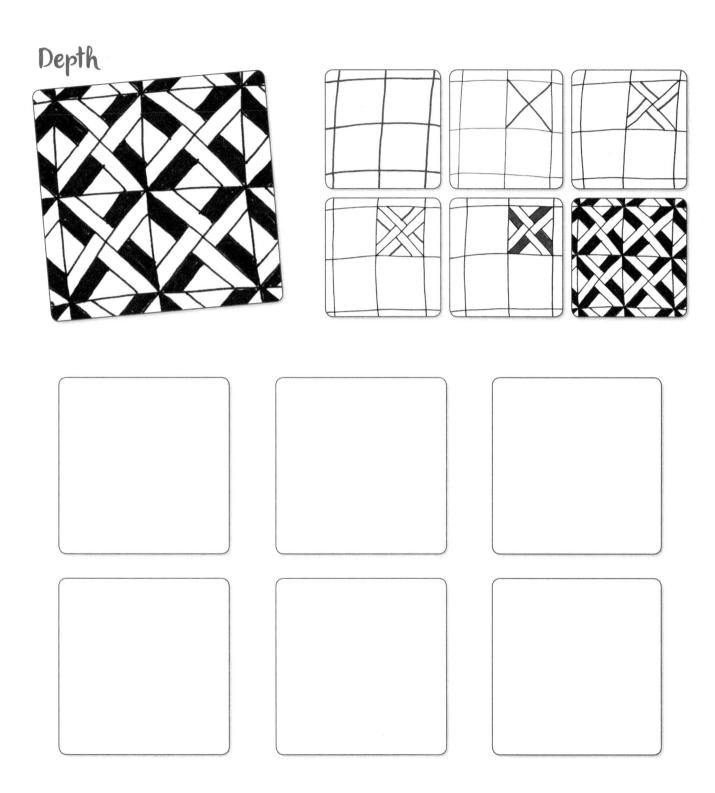

Try Adding Color

Throughout this book are some wonderful ideas for adding color to your Zendala pieces, and here is your space to practice. Try adding color to these Zendala designs. You can use anything from colored pencils and crayons to markers and watercolors. Combine the shading techniques on page 3 using your color medium of choice to create amazing depth to the designs.

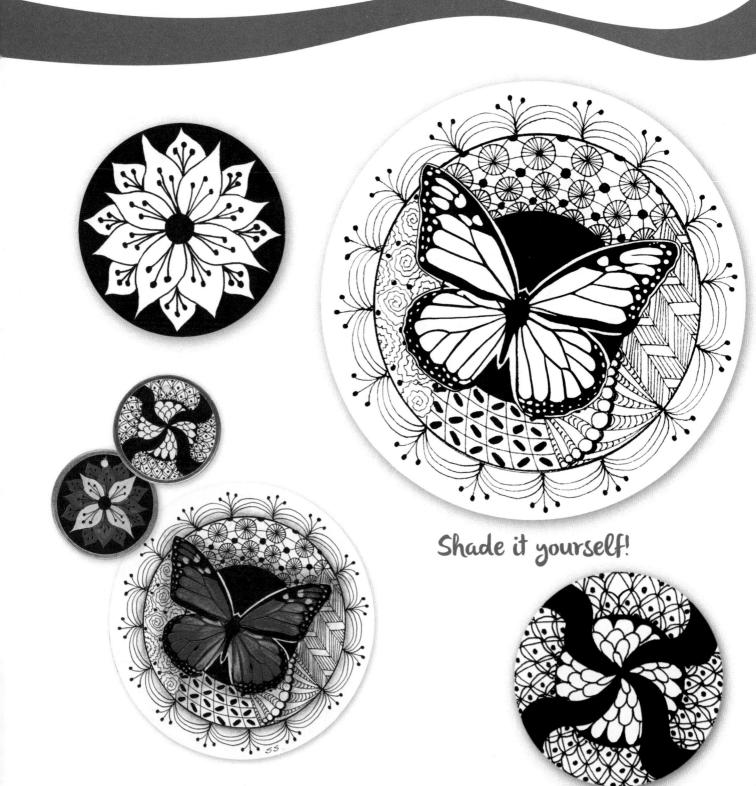

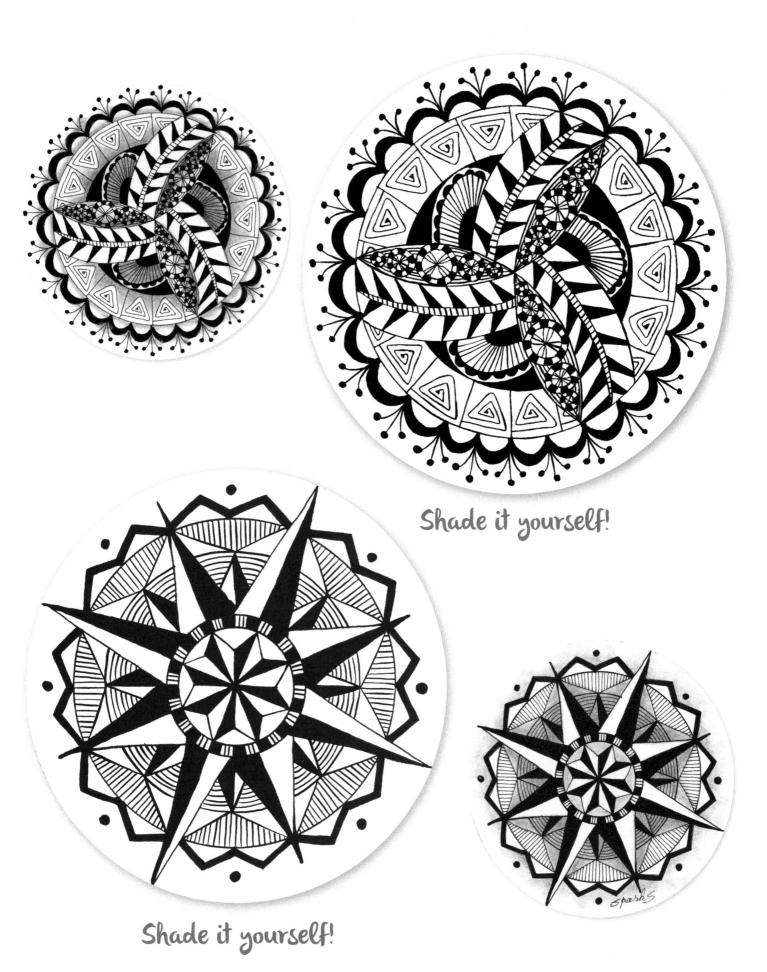

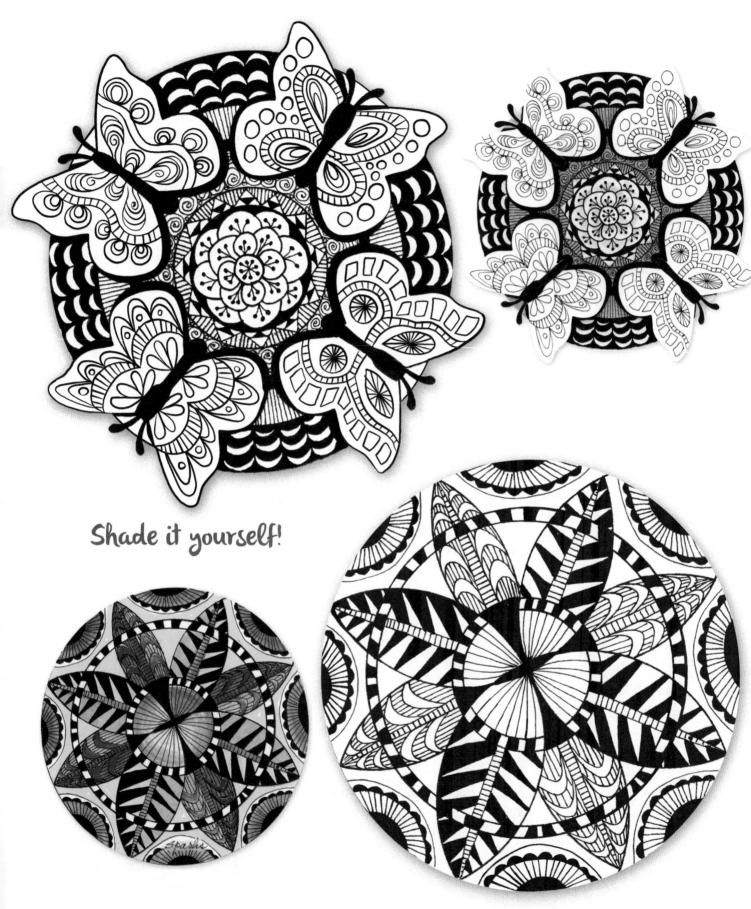

Shade it yourself!

Tangling Zendala Designs

You've seen many examples of how Zendalas can be created throughout this book. These pages contain some of the circular string outlines for you to fill in with tangles, as well as some blanks with only a border and center point for you to try your hand at creating your own string and filling it with tangles.

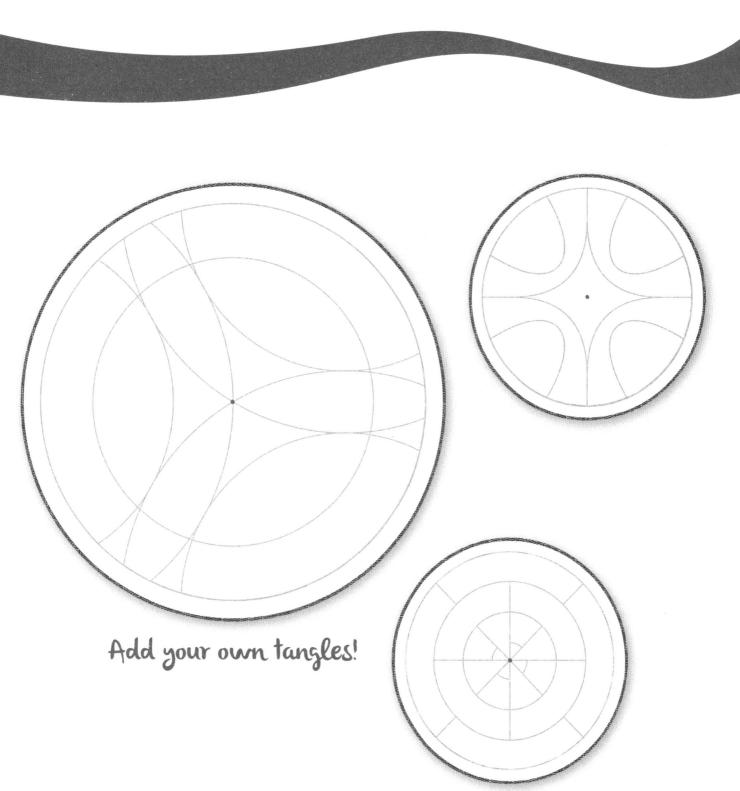

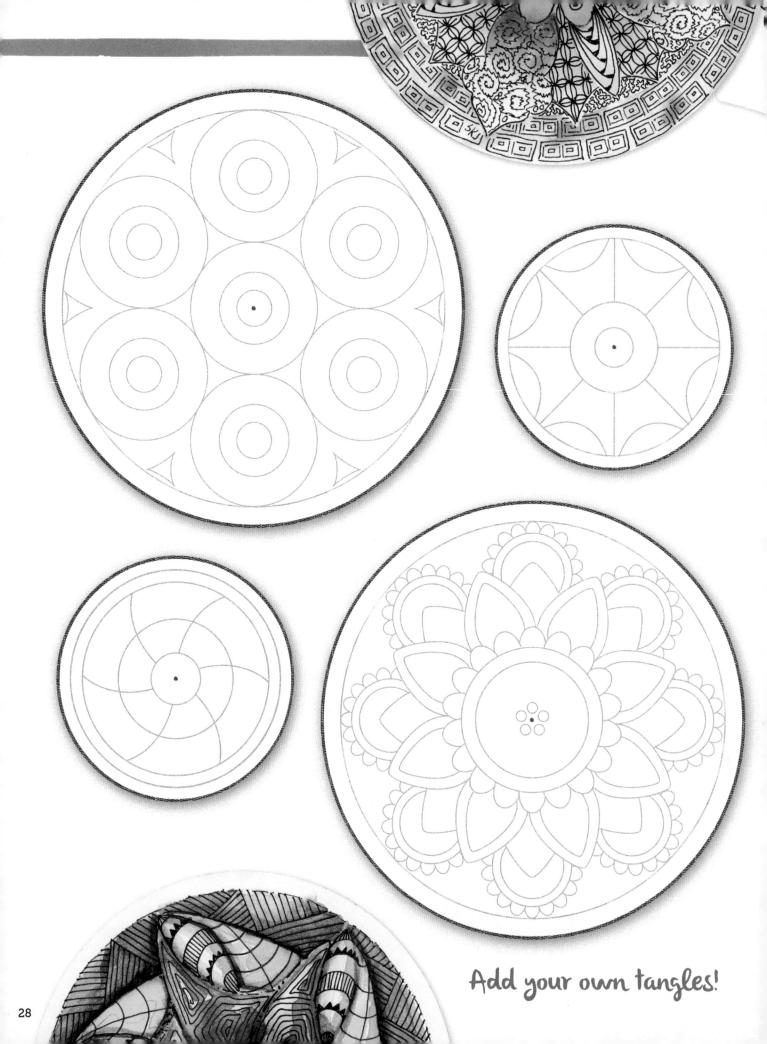

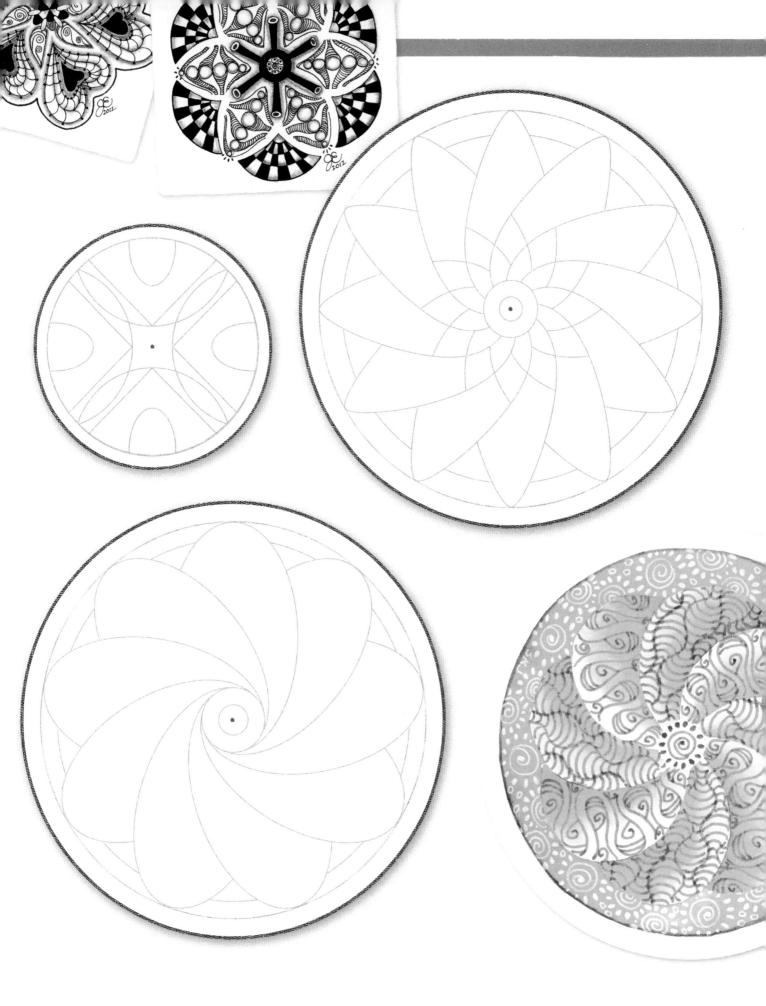

Zentangle 7 Circles, Zendalas & Shapes 29

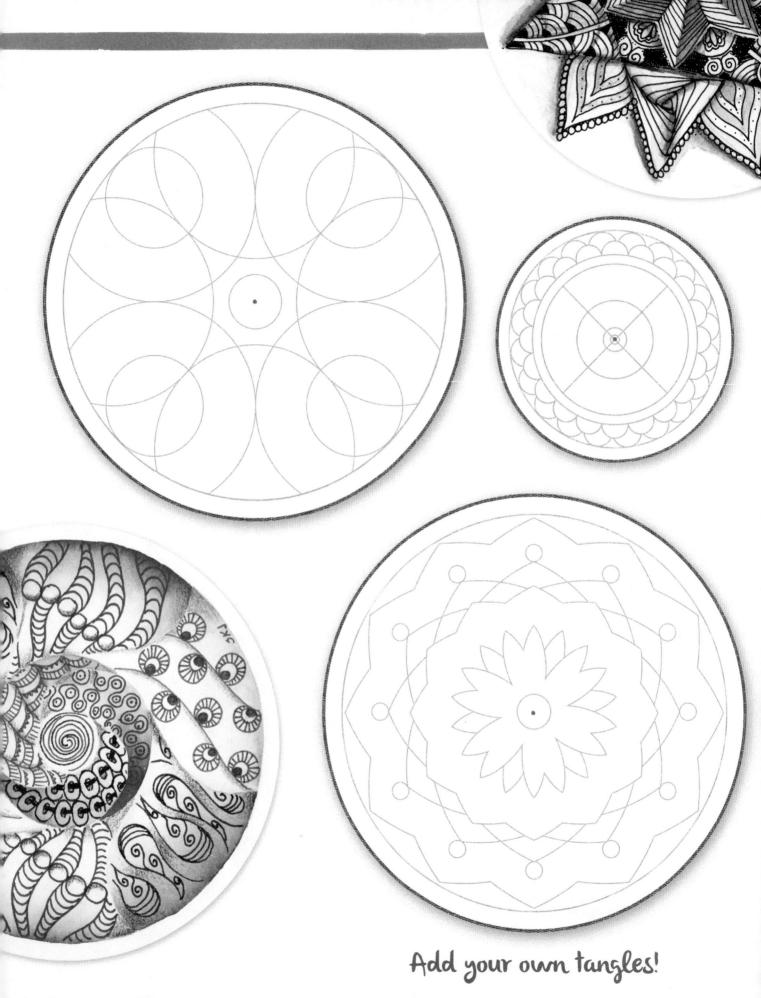